Snails & Monkey Tails

A Visual Guide to Punctuation & Symbols

Michael Arndt

Foreword by Michael Bierut

HARPER DESIGN
An Imprint of HarperCollinsPublishers

To my editor and fellow Virgo Elizabeth Viscott Sullivan

Contents

Foreword ☛

There are countless books that can teach you the alphabet, but almost none that focus on the tiny designs that run interference among the letterforms: those easily overlooked punctuation and typographic symbols. These symbols, as Michael Arndt proves in this beautiful and endlessly fascinating book, are absolutely indispensable to communication: punctuation turns words into sentences and language into meaning. How hard they work! The simple period, for instance, is a tiny dot that not only ends sentences (a role it began playing for Greek orators in the second century BCE), but also crucially governs both the digital dot-com universe (in the form of domain names) and the world of finance (ask any accountant who's ever misplaced a decimal point). And they're fascinating, too: Did you know the @ symbol—blandly called the "at symbol" by English speakers—has a fantastic name in almost every other language on earth? It's an elephant trunk in Danish, a little duck in Greek, a strudel in Hebrew, and a cinnamon bun in Swedish. It turns out that each piece of punctuation has its own tale to tell, and together they have found the perfect storyteller in Michael Arndt. This lovely book is a glorious celebration of those little marks that make a big difference. From commas to semicolons, from slashes to asterisks, from guillemets to octothorpes (named, perhaps, after athlete Jim Thorpe), you'll never look at punctuation the same way again.

—Michael Bierut, partner, Pentagram, and author of *How to use graphic design to sell things, explain things, make things look better, make people laugh, make people cry, and (every once in a while) change the world*

Preface

My father's father was a self-taught hand letterer who painted signs in New York City in the 1930s and 1940s. Fifty years later, I studied graphic design at the University of Cincinnati in Ohio, although I didn't make a connection between our professions at the time. Much later I realized that my work was a modern iteration of his. While he made deft strokes with his red sable brushes, oil-based paints, and pungent turpentine, I struggled not to make a mess with my chalky plaka and temperamental ruling pens. You see, I had really wanted to be an illustrator, not a designer, but during my second year of college I fell in love with letters, logos, symbols, and the idea that simple shapes could be both beautiful and capable of communicating meaning. That year I took Italian, which led me to rediscover much about my mother's Italian roots, so after college, I moved to the design mecca of Milan, where I continued to learn the language while I taught English. My love of both design and language led me there; those two passions led me to create this book.

Snails & Monkey Tails is an exploration of the fourteen standard punctuation marks in the English language and its most commonly used typographic symbols. To me, these marks and symbols are the jewels that sparkle against the little black dress of typography. This book shows how they dazzle across typefaces and the fascinating ways in which their names and shapes evolved. Some of these origins are speculative, but they're intriguing nonetheless. Also included are sample grammatical uses of each mark. My wish is that this book will be the beginning of discovering...or rediscovering with fresh eyes...the beauty, function, and yes—even joy—of punctuation!

Punctuation
& Symbols

PUNCTUATIONHASNOTAL

Punctuation has not always existed. In ancient…

GWASWRITTENINALLCAPS

ASLOWERCASEDIDNOTEXIS

as lower case did not exist yet. Furthermore, there…

NWORDSTHESENTENCES

WEREWRITTENLEFTTORI

were written left to right then right to left…

SCALLEDBOUSTROPHEDON

WAYSEXISTEDINANCIENT

NIHTYREVEGNITIRWKEERG

Greek writing, everything was written in all caps

TYETFURTHERMORETHERE

WERENOSPACESBETWEE

were no spaces between words. The sentences

GHTTHENRIGHTTOLEFTIN

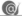

ALTERNATINGOXPLOWROW

in alternating ox-plow rows called *boustrophedon*.

The practice of not using any punctuation is a trend on social media but it makes it harder to read without knowing when to take a break distinguish between parts of sentenc or tell the difference between its and its See what I mean Its hard to even know the tone or if a question is being asked or if somethings plural or a contraction Ironically exclamation points are overused!!!!!!!!!!!!!

Poor or missing punctuation can impede clarity and slow down reading.

Likewise, using too much punctuation or using it incorrectly also creates confusion.

Punctuation ·········

From the Latin

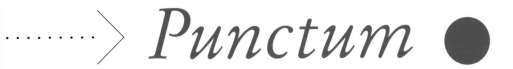

Punctum

which means a **point**

Aristophanes of Byzantium, librarian of Alexandria, invented one of the first forms of punctuation, a series of dots called *théseis* (Greek) or *distinctiones* (Latin). These dots were designed for orators to signal the amount of breath to take after verses. A short verse (*komma*) was marked with a dot placed at the center of the line; a longer one (*kolon*) at bottom center; and a very long one (*periodos*) at top center. The names of the dots are seen in the modern **comma, colon,** and **period.**

SECOND CENTURY BCE

SEVENTH CENTURY CE

In the seventh century CE, Isidore of Seville reorganized the dots. In his medieval encyclopedia *Etymologiae*, he prescribed that the *komma, kolon,* and *periodos* be located more logically at the bottom, middle, and top, respectively. This time saw the birth of the *punctus interrogativus* (early question mark) and the *diple* (›), from *diplous*, which means **double** and refers to the two lines in the mark itself (›). The ancient Greeks positioned the symbol in manuscript margins to indicate noteworthy text, which in those days, as manuscript scribes were most often monks, was synonymous with "from the Bible." Guillemets (« ») and quotation marks (" ") have their roots in the *diple*.

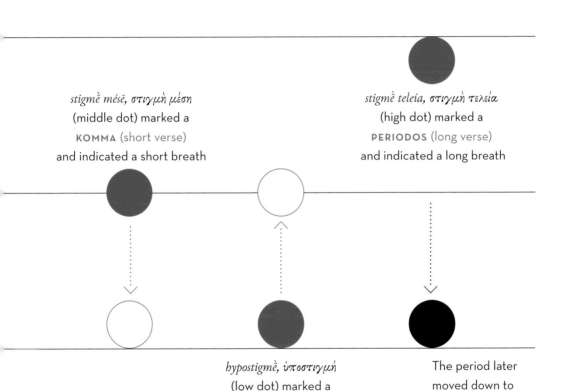

stigmè mésē, στιγμὴ μέση
(middle dot) marked a
KOMMA (short verse)
and indicated a short breath

stigmè teleía, στιγμὴ τελεία
(high dot) marked a
PERIODOS (long verse)
and indicated a long breath

hypostigmè, ὑποστιγμή
(low dot) marked a
KOLON (medium verse)
and indicated a medium breath

The period later
moved down to
the baseline.

The
word **period** comes
from the Greek *periodos*,
(**cycle** or **circuit**)—or more literally
peri- (**around**) + *hodos* (**way/course**).
In Commonwealth English it is known as
a **full stop** for its use to end a declarative
sentence. As it evolved from Aristophanes'
distinctiones, it can be considered the oldest
punctuation mark in the English language.
It is nearly impossible to say whether
the period or the comma is the
most commonly used
mark.

Period / Full Stop

Periods can be many shapes.

round

square

oval

rectangular

curvy

diamond

Japanese periods, called ideographic full stops, are hollow circles (。).

Periods are used

to end sentences My dog is cute.

for abbreviations etc.

in domain names www.website.com

as decimal points $1.00

and in Europe as thousands separators €1.000.000

Periods are not used in titles, subtitles, headlines, or subheads.

Asterisk
comes from the Greek
word *asteriskos* (**little star**). The
same root word is used in the words
*astro*naut, *aster*oid, and *aster*. Aristarchus of
Samothrace developed the mark in 300 BCE to
mark lines that were duplicated. The original
asterisk was a crisscross with four dots (※).
Today, glyphs of it can have four to eight or
even ten points. San serif typefaces
tend to have five (*) while serif
often have six (*).

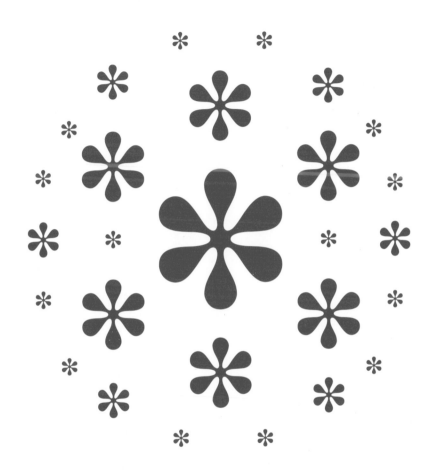

Asterisk

Asterisks can look like little STARS

*

or *snowflakes*.

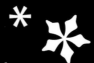

Some look like flowers with varying numbers of petals.

Use asterisks to show missing letters in swear words.
Doing so is called **expurgation** or **bowdlerization**.

d*mn!

Asterisks can be used to show *emphasis* where type cannot be styled—e.g., texts, social media.

A **grawlix** is a string of punctuation used in cartoons for swear words.
The term was invented by *Beetle Bailey* cartoonist Mort Walker.

Asterisks are also used on social media and in texts for self-described "stage direction"—e.g., *sigh*.

Dinkus

Three asterisks in a row are used to show a section break in writing.

Asterism

The triangular formation is a nearly obsolete variation of a dinkus.

An asterisk can be used to indicate the year of birth.

William Shakespeare *1564

William Shakespeare †1616

Similarly, the dagger can indicate the year of death.

Asterisks are often used for a first footnote.*

*A footnote appears at the bottom of a page in smaller type and provides the source of information or clarifies it.

 The asterisk denotes the **star** key on phone keypads.

When the first footnote is indicated by an asterisk, the subsequent symbols follow this standard order. If more than six are needed, simply repeat the order, but double the symbol—i.e., ** > †† > ‡‡ > §§ ...

2	†	Single dagger (obelisk)
3	‡	Double dagger (diesis)
4	§	Section mark (silcrow)
5	‖	Vertical bars
6	¶	Paragraph mark (pilcrow)

The asterisk and the obelisk inspired the names of the French comic book characters Astérix and Obélix.

*
8 On computer keyboards, asterisks perform the multiplication function.

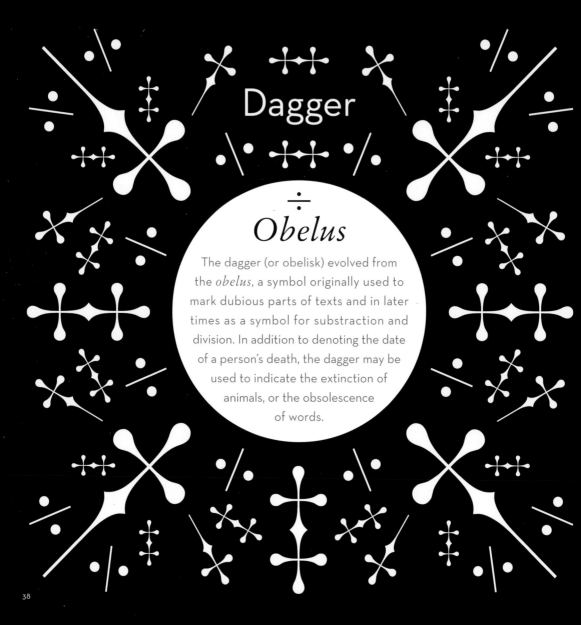

Dagger

÷

Obelus

The dagger (or obelisk) evolved from the *obelus*, a symbol originally used to mark dubious parts of texts and in later times as a symbol for substraction and division. In addition to denoting the date of a person's death, the dagger may be used to indicate the extinction of animals, or the obsolescence of words.

Section Mark

(Silcrow)

The elegant
section mark, also referred
to as the silcrow, is formed by joining
two **s** shapes together. The letters stand
for *signum sectionis*—i.e., **section symbol**.
While used as a footnote symbol, the silcrow
appears more often in legal documents, where
it is followed by number marking a particular
section or statute, such as "See document C,
§ 165." An altered section sign is used in the
video game *The Sims* as the symbol
for its imaginary currency,
the Simoleon.

Vertical Bars

Vertical bars
and double vertical bars
have specific applications in
mathematics, science, language,
and coding. In coding they are called
pipes after their use as a conduit to allow
programs to communicate with each other.
Double bars with spaces on either side in
poetry can mark breaks between feet or
phrases called *caesura* (plural *caesurae*),
from the Latin *caedere* (**to hew /
cut down / chop**).

¶ The pilcrow was first used to mark chapter headings, or *capitula* (**chapters** / **little heads**), and later used to mark paragraphs. It is still used that way as an "invisible" mark in software programs. The symbol was created from the letter **c** (not a **p**), to which vertical bars were added. Its name evolved from the Greek *paragraphos*—from *para* (**beside**) and *graphein* (**to write**)—to the Old French *pelagreffe*, to the Middle English *pylcrafte*, finally arriving at **pilcrow**.

Pilcrow

¶ Pilcrows were rubricated (lettered in red, from the Latin *rubricare*, to **redden**) by medieval monks known as **rubricators** to indicate the beginning of paragraphs.

Indents in medieval manuscripts left room for pilcrows, to be added by hand, even after the invention of the printing press. Eventually, the rubricated mark was abandoned, though the indentation remains.

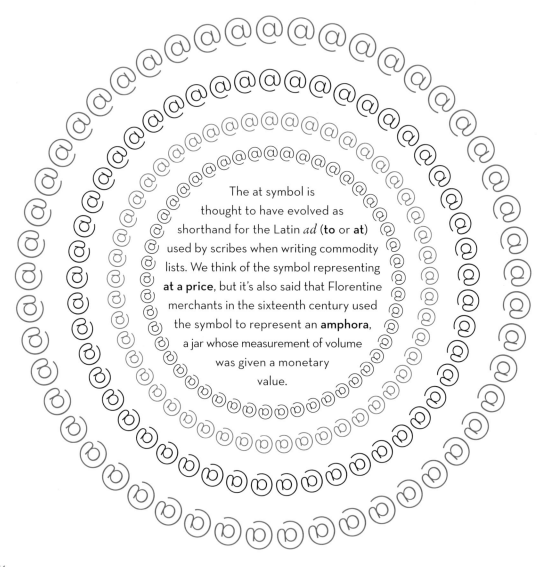

The at symbol is thought to have evolved as shorthand for the Latin *ad* (**to** or **at**) used by scribes when writing commodity lists. We think of the symbol representing **at a price**, but it's also said that Florentine merchants in the sixteenth century used the symbol to represent an **amphora**, a jar whose measurement of volume was given a monetary value.

At Symbol

There have been attempts to give the at symbol more
official-sounding names such as **asperand** or **ampersat**.
Easily confused with **ampersand**, neither term has caught on.

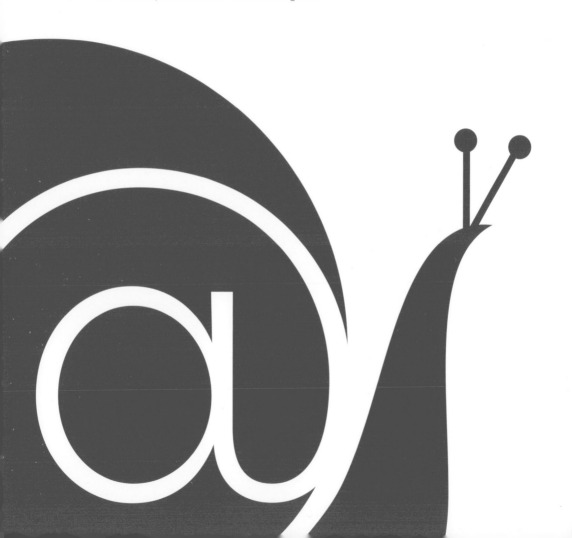

The at symbol (sign) has various charming nicknames in other languages.
Italians call it *chiocciola* (snail).
Germans call it *Affenschwanz* (**monkey's tail**).

Other amusing names include:

Czech and Slovak | *zavináč* (**rollmops—i.e., rolled pickled herring**)

Danish | *snabel-a* (**elephant trunk**) or *grisehale* (**pig's tail**)

Finnish | *kissanhäntä* (**cat's tail**)

Greek | *papáki* παπάχι (**little duck**)

Hebrew | לדורטש (**strudel**)

Hungarian | *kukac* (**little worm**)

Russian | soba[ch]ka *соба[ч]ка* (**[little] dog**)

Swedish | *kanelbulle* (**cinnamon bun**)

Taiwanese | *xiǎo lǎoshǔ* 小老鼠 (**little mouse**)

Characters: letters, numerals, punctuation, and symbols that serve different linguistic functions (e.g., A / a / b / ?).

Typeface: the cohesive style of a set of characters designed to be used together (e.g., **Neutra** / Garamond).

Font: the smallest complete set of physical characters needed to fully reproduce a typeface in any given variation (e.g., **Neutra Demi Bold** / **Garamond Italic)** and size (e.g., **10 point** / **12 point**).

Glyph: any visual variation of an individual character (e.g., **b** / *b*).

Thirteen fonts were used to print these thirteen glyphs from varied typefaces, but all of the same character (@).

The @ symbol is used to show rate in commerce:

7 apples @ $2 each

to separate a username from a domain name in an email address:

name@website.com

to tag a profile on social media:

@aprofilename

Percent Sign

The percent sign
evolved from the Italian *per cento*
(**for one hundred**), often abbreviated as
p 100 or *p cento*. A manuscript from the fifteenth
century hows the use of the abbreviation *pc°*, a **p**
with an elongated **c** with a superscript ° at its terminal.
Over time the **c** closed into a circle with the small **o**
above the horizontal stroke as the **p** slowly vanished.
Lastly, the symbol assumed its present-day diagonal
orientation. In English, there is no space
between the number and the symbol;
there is a space in Spanish and
French.

A *per mille* symbol (‰) is used to mark thousandths. A *permyriad* symbol (‱) is used to mark ten thousandths.

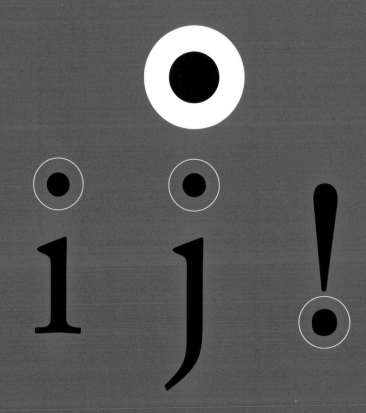

Tittle

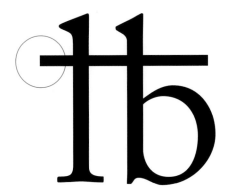

The noun
tittle means "a tiny part
of something" and also refers to
the diacritical marks, or dots, that appear
appear below the ! and above the letters i
and j. In its stroke form, it was used to join two
letters in abbreviations and to show that letters
were missing. The abbreviation **lb**, for pound, is
one example. Although the tittle did not remain
in general usage, it was retained by apothecaries.
Titulus, the Latin root of tittle, gave rise
to the words **title** in English and
tilde (**accent mark**) in
Spanish.

In Latin, the word *libra* means a **balance (scale)** once used exclusively to weigh things for sale. It is also the constellation that inspired the zodiac sign of the same name and its attributes— i.e., valuing justice and seeking personal balance.

Libra Pondo

Libra pondo was the weight of a pound of silver and came to stand for both weight and currency. The word *pondo* gave us the English word **pound**—an etymological cousin of the Spanish *peso*—while the word *libra* was abbreviated as lb. and as the monetary symbols £ and £, both of which retained the tittle.

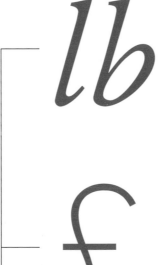

pound
unit of weight

abbreviated to

British pound
monetary unit

Italian lira
monetary unit before
the euro (€)

The pound sign is one of many punctuation symbols that developed from shortcuts made by scribes who had to write abbreviated words repeatedly, which resulted in abstracted marks.

The *lb* abbreviation for pound became a symbol when handwritten with a tittle across the **l** and **b**. The symbol was eventually simplified into the crisscrossing sets of parallel horizontal and diagonal lines (#) that create the more modern variant of the pound sign.

The pound sign is sometimes called octothorp(e) for its eight points (*octo* means **eight** in Latin). The **thorpe** is believed to have been a tribute to athlete Jim Thorpe, a personal hero of the advertising man who is believed to have come up with the name in the 1960s for Bell Labs' new Touch-Tone key.

Pound Sign

(Number Sign / Octothorpe / Hash)

Whether you
call this symbol a pound,
number, or hash sign may very well
indicate your generation. The hash sign,
as it's most often called these days, may
have its origins in ancient Roman times, but it
is experiencing a reinvention in the age of the
internet. Twitter's first use of it can be traced to
August 23, 2007, when blogger Chris Messina
used it to create a way to filter channels of
information. The **tag** portion of hash**tag**
refers to the word(s) that
follow the hash.

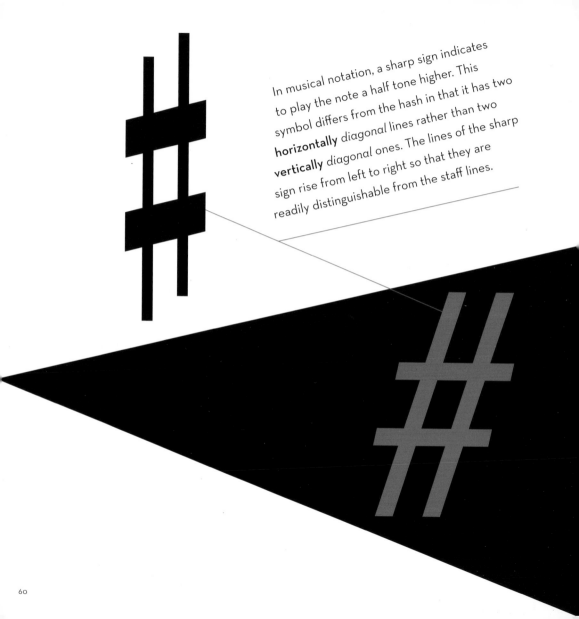

In musical notation, a sharp sign indicates to play the note a half tone higher. This symbol differs from the hash in that it has two **horizontally** diagonal lines rather than two **vertically** diagonal ones. The lines of the sharp sign rise from left to right so that they are readily distinguishable from the staff lines.

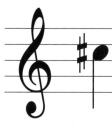

The uses of the # include:

pound key on telephone

hash sign for internet tags # tag

three at the end of a press release the end. ###

number sign #2 pencil

checkmate in chess notation #

proofreader symbol to insert#space

Ligature

A combination of two or more letters, from the Latin *ligare* (**join** or **link**).

Typographic ligatures are done for visual purposes.

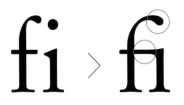

Standard typographic ligatures simplify adjacent letterforms that conflict or crash with each other:
Th fb ff fh fj fk fl ft ffb ffh ffi ffj ffk ffl fft

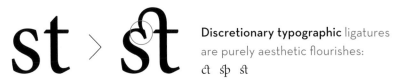

Discretionary typographic ligatures are purely aesthetic flourishes:
ct sp st

Orthographic ligatures are used for linguistic purposes.

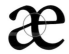

The **æ** can be found in the mostly archaic spelling of names such as Æsop and Cæsar. Many words once spelled with this ligature are now spelled with the **a** and **e** separate, or the **e** alone—e.g., encyclopædia > encyclopedia.

The **æ** is its own letter in the Danish and Norwegian alphabet:

a b c d e f g h i j k l m n o p q r s t u v w x y z æ ø å

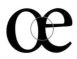

The **œ** can be found in the mostly archaic spelling of Greek words such as Œdipus and onomatopœia.

The **œ** is a digraph (two letters merged to form one sound) in modern-day French where it is called an *e dans l'o* (**e in an o**). It appears in words such as *hors d'œuvres*, *œuf* (**egg**), and *trompe l'œil* (**trick of the eye**).

As the name suggests, the letter **w** is the result of a double **u** or **v**, letters that have intermingled throughout history. In Italian, the **w** is called a *doppia vu* (**double v**). In German, the **w** still has a **v** pronunciation whereas in Welsh, **w** can be a **u**-sounding vowel.

E+t

=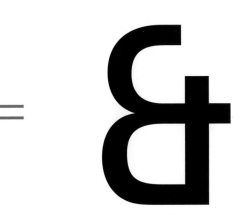

Some modern typefaces (such as Zurich BT Roman shown here) have ampersands that reflect the symbol's origins as a ligature of the letters **e** and **t**.

The
ampersand is a logogram—
i.e., a character or a symbol that
represents an entire word, as Chinese
characters and hieroglyphics generally do.
It is a typographic evolution of the letters
in the word *et*, which means **and** in Latin.
The **e** and **t** were written over and over
and simplified until they became the
symbol we know today that
resembles a twisted figure
eight (8).

Ampersand

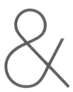

Esperluette is the French term for ampersand, from the Old French *es per lou et (c'est pour le et)*— i.e., **this is for the and.**

A B C D E F G H I J K L M N O P Q R S T U V W X Y Z &

amd *per se* and

The peculiar
word **ampersand** originated
as a mondegreen (i.e., a mishearing
or misinterpretation of a word or phrase
that gives it new meaning) of "**and** *per se* **and**."
Letters that could also double as words—i.e., **A**, **I**,
and at one point **O**—would be preceded by *per se*
(**by itself**) in order to distinguish the word from the
letter. Hence, (the letter) **a** *per se* (is the word) **a**,
i *per se* **i**, and **o** *per se* **o**. Traditionally, the **&**
was recited last as if it were the final
letter of the English alphabet,
thus **&** *per se* **and**.

LETTER

#27

There is a wide variety of glyphs that represent the ampersand character.
In some typefaces, it resembles a plus sign (+), which is also an evolution of the word *et*.

peanut butter

Sonny

black

Bogey

bed

Adam

Q

Tiffany

An ampersand replaces the word **and** in informal writing.

salt

It is used with famous pairings and in certain company names.

Gilbert

In the nineteenth century, it preceded **c** to stand for **et** in the abbreviation of et cetera (**&c = etc.**).

cats

Lewis

R

Bonnie

bread

Romeo

bacon

Currier

gin

AT

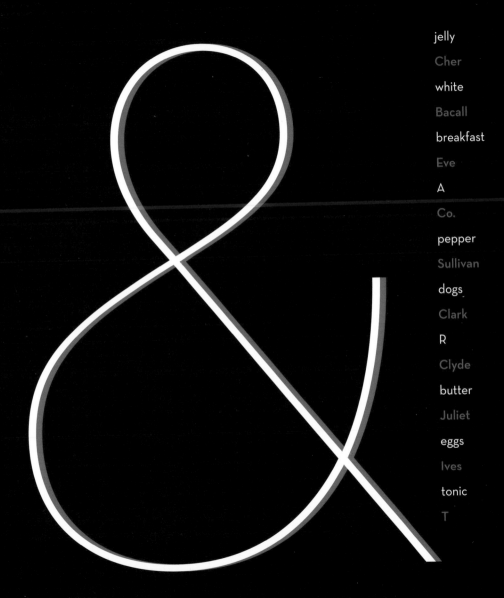

jelly
Cher
white
Bacall
breakfast
Eve
A
Co.
pepper
Sullivan
dogs
Clark
R
Clyde
butter
Juliet
eggs
Ives
tonic
T

Slash / Virgule

(Forward Slash / Slant / Diagonal / Oblique / Separatix / Scratch Comma)

Tuscan writer
Boncompagno da Signa
invented a two-symbol system of
virgulae (singular, *virgula*, Latin for **twig**)
in the twelfth century as a proposal to replace
the *distinctiones*. The *virgula suspensiva* (/) was
employed for a short pause within text whereas the
virgula plana (–) was used for a pause at the end.
It was eventually phased out and replaced by
the *suspensiva*, which also made its way to the
baseline and added a curve to become the
comma we know today. *Virgule* is still
the name for comma in
French.

/ Slashes typically do not have a space before or after, but designers often choose to add them on either side for visual clarity, especially when separating entries with more than one word, as shown above.

The word slash harkens back to the sixteenth century for the act of slicing with a knife or a weapon. It is believed to have come from the Old French verb *esclachier* (**to break**).

? / Using the keyboard slash will perform the division function on computer calculators.

options (*or*) coffee / tea

abbreviations c / o = care of

rate (*per*) 65 / mph

opposition (*vs.*) pro / con

same line fractions (÷) 1/2 sandwich

dates MM / DD / YY Europe prefers DD/MM/YY
Asia prefers YY/MM/DD

http web protocol http: // www.domain.com /

Mary had a little lamb / little lamb, little lamb

to separate lines of a poem, song, or play

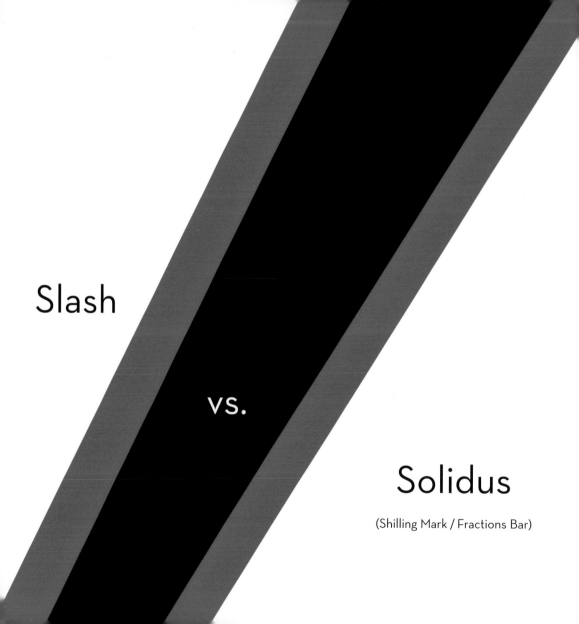

Slash

vs.

Solidus

(Shilling Mark / Fractions Bar)

The function of
the solidus is to divide the
numerator and the denominator in
a diagonal fraction. The solidus is thinner
than the slash, has a less steep angle, and
does not extend beyond the baseline. Its
name comes from an ancient Roman gold
coin, a precursor to the British shilling.
The symbol evolved from the archaic
long **s** (∫) abbreviation for shilling,
once a fraction of the
British pound.

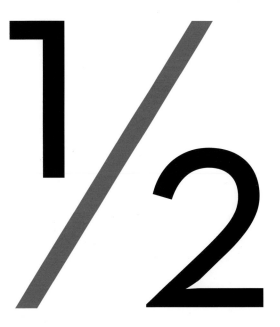

While
its origin is uncertain,
the exclamation point is thought
to have originated in Latin from *io*,
an expression of joy, in which the capital I
came to be written over the O. The exclamation
point is possibly overused in the digital age, but
it did not have its own key on typewriters until
1970! Instead, one had to backspace and
type an apostrophe over the period (!).
In Spanish, an inverted exclamation
point begins a sentence.
¡Olé!

Exclamation Point

You
only
need
one.

Using

several

is

redundant
redundant
redundant
redundant
redundant

!

One exclamation point can also be more **visually** powerful

!!
!!
!!
!!
!!
!!
!!
!!
!!
!!
!!
!!
!!
!!
!!
!!
!!
!!
!!!!!!!!!!!!!!!!!!!!!!!!!!!!!!!!!!! than too many !!!!!!!!!!!!!!!!!!!!!!!!!!!!!!!!!!!!!
!!
!!
!!
!!
!!
!!
!!
!!

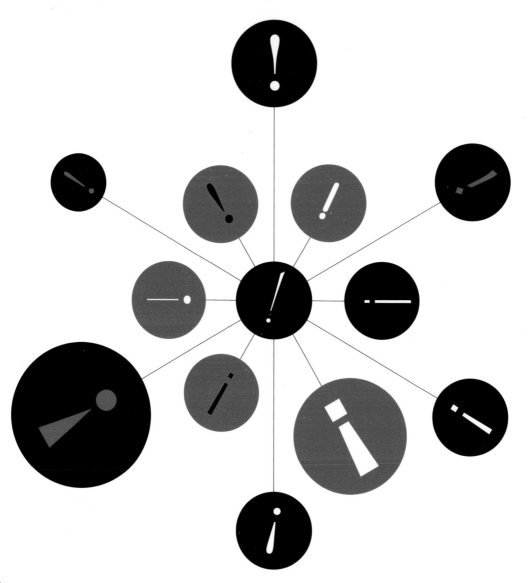

Exclamation points can be used for interjections, emphatic statements, expletives, and commands.

WOW!

Yes!

OUCH!

eeeeek! STOP!

UGH!

Exclamation points, much like ALL CAPITAL LETTERS, can express loudness.

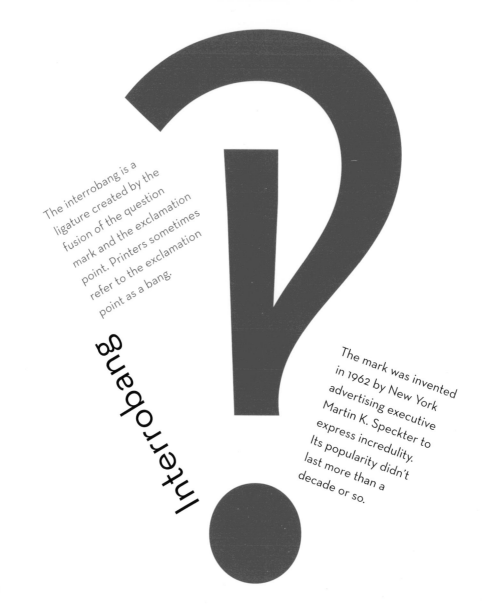

The interrobang is a ligature created by the fusion of the question mark and the exclamation point. Printers sometimes refer to the exclamation point as a bang.

Interrobang

The mark was invented in 1962 by New York advertising executive Martin K. Speckter to express incredulity. Its popularity didn't last more than a decade or so.

Percontation Point

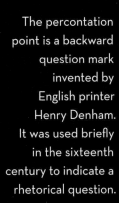

The percontation point is a backward question mark invented by English printer Henry Denham. It was used briefly in the sixteenth century to indicate a rhetorical question.

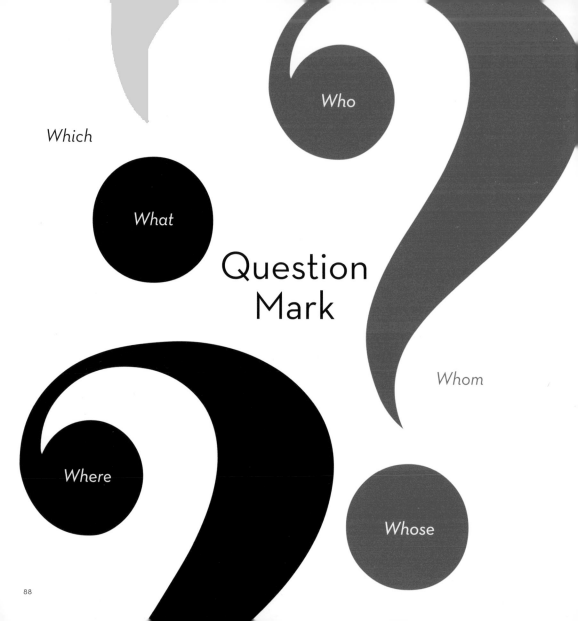

Which

Who

What

Question
Mark

Whom

Where

Whose

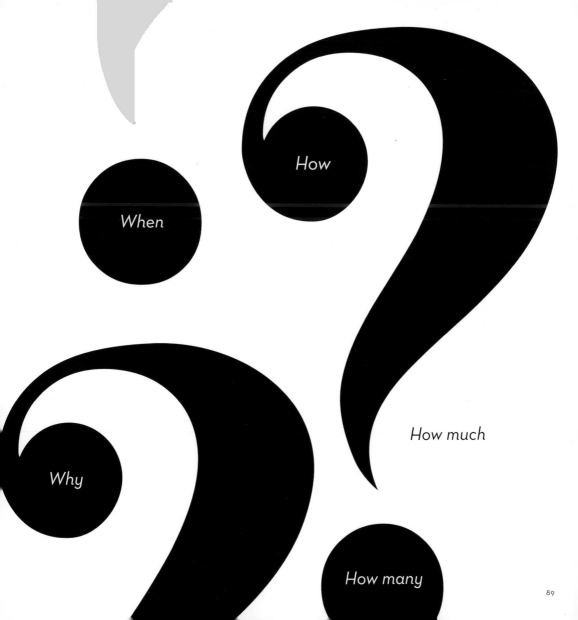

When

How

Why

How much

How many

89

quaestio

q

o

?

?

There are three stories about the origin of the question mark. 1. Scholars in the Middle Ages would place the Latin word *qvaestio* (**question**) at the end of questions. It was later abbreviated to **qo**, and, over time, the **q** was written over the **o** to form one character, similar to how the exclamation point came about. 2. A cat is considered curious; hence the story that its tail inspired the shape. 3. The most credible is that it developed from the *punctus interrogativus* in the eighth century, a point with a tilde-like lightning flash above it.*

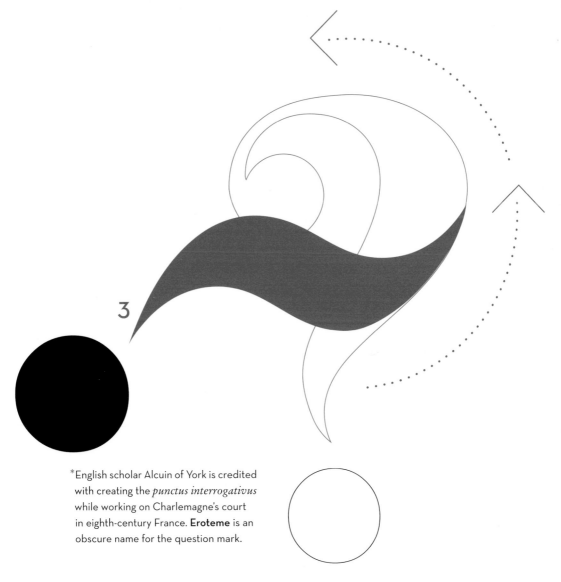

3

*English scholar Alcuin of York is credited with creating the *punctus interrogativus* while working on Charlemagne's court in eighth-century France. **Eroteme** is an obscure name for the question mark.

¿Qué es esto?

In Spanish, an upside-down question mark begins a question.

Qu'est-ce que c'est ?

In French, it is customary to add a space before the question mark.

Τι είναι αυτό;

In the Greek alphabet, the question mark resembles a semicolon.

The head of the question mark faces right in Arabic, Persian, and Urdu as these languages read from right to left. Hebrew is also written right to left, but the head of the question mark faces left.

Use **question marks...**

to ask a direct question:

What is your name?

in questions quoted word for word:

She asked, "What is your name?"

in question tags:

That is your name, isn't it?

Do NOT use question marks...

in reported (indirect) speech:

She *asked* me what my name *was*.

NOTE: the verb follows the noun as it does in a statement and
the *verbs* are in the *past tense*.

in statements beginning with **wonder** or **guess**:

I wonder what her name is.
Guess what my name is.

NOTE: the verb follows the noun as it does in a statement.

Some people prefer periods or exclamation points with rhetorical questions.

How dare you call me that name!

Brackets

Brackets (round, square, and curly) are commonly used to group mathematical expressions in this order: {[()]}. This configuration is called **nested parentheses.**

Parentheses

There are three types
of brackets: round, square,
and curly. The word **bracket** comes
from the French *braguette* (**codpiece**).
Round brackets, or **parentheses** (singular
parenthesis), are by far the most common.
Parenthesis is from the Greek *parentithenai*
(**a putting in beside**) and is used in pairs
to enclose information that is additional,
but not integral, to a sentence. In
mathematics, parentheses are used
to group numbers in the order
of operations.

round

BRACKETS

Brackets
(known also as square brackets)
are used within a quotation to frame
words added by an author to a citation of
another author's work to clarify meaning or to
signal the adjustment of a word's form to make it
grammatically correct in the context of the sentence.
Brackets also enclose the word **sic** [*sic*], which is
placed in quoted text after errors made by the
original author. Brackets can be used to hold
ellipses [...] and to create a double
enclosure (a second enclosure)
within parentheses.

SQUARE

Braces

As elegant as they are, curly brackets (braces) are not used in prose or in formal writing. They are found in musical scores (where they are called **accolades**) to join two or more staffs (also known as staves). Similarly, they can refer to lines of poetry that are meant to be repeated. Braces are also used in mathematics. In computer programming, they enclose groups of statements and blocks of code.

curly

The word **brace** comes from Old French *bracier* (**to embrace**), from the Latin word for arms. It is no surprise then that braces are used in emoticons to signify a hug. { }

Avoid overusing parentheses.

The use of parentheses is effective for indicating a side note or very brief commentary. The overuse of parentheses may slow down reading or interrupt text flow, diminishing clarity. If information is important enough to include in a piece of writing, don't present it parenthetically.

Parentheses can be used to set off an aside afterthought.

She came to the conclusion that Jim was a cad (after all, he'd had three wives in three years).

If the afterthought is part of a sentence, the period is set on the outside of the closing parenthesis.

She came to the conclusion that Jim was a cad. (After all, he'd had three wives in three years.)

If the afterthought stands alone as a complete sentence, the period is set inside the closing parenthesis.

They are commonly used to define terms or translations.

the usual diagnostic tests (mammogram and a sonogram)

instructions for making your own bookshelf (see page 6)

What matters most are the little things (*les petites choses*).

What matters most are *les petites choses* (the little things).

Use **brackets** (originally from the Latin word [*braca*] for "breeches") for parenthetical information within parentheses.

Guillemets

The word **guillemet**
comes from the diminutive for
the French name Guillaume (**William**)
after typecutter Guillaume Le Bé, who is
dubiously credited with their invention. They
take the form of pairs of single (‹ ›) or double (« »)
chevrons and are thus sometimes confused with the
lesser- and greater-than signs ($<$ $>$) in mathematics or
the angled brackets (〈 〉) used in Chinese, Japanese,
and Korean. They are typically not used in English.
In a malapropism, Adobe Systems font software
misspelled guillemet as guillemot, which is
a type of seabird. Adobe has
acknowledged this error.

In Irish, the guillemet is referred to as a *liamóg*,
the diminutive form of Liam (**William**).

Proper quotation marks often resemble the numerals 66 and 99.

Quotation marks,
like guillemets, have their roots
in the diple (<). With the advent of printing,
the use of the diple to indicate noteworthy text
gave way to quotation marks in their present-day
form. It was not only difficult to print in the margin, but
printers did not have a piece of type for the symbol. They
pressed the comma into service; to avoid confusion with its
usual usage, they doubled it, raised it from the baseline, and
inverted it (quotation marks can also be referred to
as "inverted commas"). While the form of this notation
varies worldwide, quotation marks universally
indicate quoted speech as well as the titles
of songs, poems, short stories,
essays, and articles.

Quotation Marks

Marks used to show quoted material vary among languages in shape and composition.

QUOTATION MARKS

"English"
(American)

'English'
(Commonwealth)

"Hebrew"
"Swedish"

„Hungarian"
„Polish"

„Czech"
„German"

GUILLEMETS

«Arabic»
«Greek»
«Russian»

« French »
(French uses dividing spaces)

»Danish«
(and sometimes »German«)

HOOK BRACKETS

「Japanese」

鉤括弧 (かぎかっこ)
kagikakko are the
quotation marks
used in Japanese

Quotation Marks may be single or double and straight or curly.

single double

Straight quotes are straight up-and-down marks. They are often referred to as **dumb** quotes because they use the same symbol at the beginning and the end of cited material. A vestige from the typewriter era, when keyboard space was limited, they have a neutral shape, which meant they could be used for other marks. Straight quotes are still the default on most keyboards, but their use in professional typography is discouraged.

Curly quotes—also called proper, typographer's, or **smart** quotes— are quotation marks that have different versions for indicating the opening and closing of cited material. They may be curved, square, or angled (also called sloped), but they are never straight up and down. Most have opening quotes in which the heavier part sits at bottom; the closing quote is simply the opening quote rotated 180 degrees so the heavier part sits on top. A few typefaces have mirrored quotes in which the heavier part is always on top and the bottom points inward toward the quoted material.

" Curly "

" Square "

Smart quotes

" Angled "

" Mirrored "

Prime Marks

While they may be
straight up and down, which
can cause them to be confused with
straight quotes, prime marks, in most
typefaces, taper and slant the same way closing
quote marks do, which can cause them to be
confused with sloped quotation marks. Prime
marks are usually used in single or double
form, but are sometimes used in triple or
quadruple form. Unfortunately,
many typefaces lack proper
prime marks. ✳

Prime marks are employed in a range of fields from mathematics and science to music and linguistics, but the uses below are the most common.

Use single prime marks to show feet and double prime marks to show inches.

He is 6′2″ tall.

* Using *italicized* straight quotes is considered an acceptable alternative to prime marks.

He is 6′2″ tall.

Never use smart quotes in place of prime marks.

~~He is 6′2″ tall.~~

Also use single and double prime marks for arcminutes and arcseconds of degrees, respectively, when describing latitude and longitude coordinates.

40° 46′ 7.4136″

ʻOkina

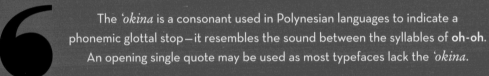

Hawaiʻi

6 The *ʻokina* is a consonant used in Polynesian languages to indicate a phonemic glottal stop—it resembles the sound between the syllables of **oh-oh**. An opening single quote may be used as most typefaces lack the *ʻokina*.

Single Quotes

Like double quotes, single quotes can be opening or closing and come in the same variety of forms. In most typefaces the closing single quote has the same design as the apostrophe.

Just as there are differences in spelling and word usage in American and Commonwealth English, there are some punctuation differences too. The biggest difference is the punctuation of quotations.

Commonwealth English

In Commonwealth English: single quotation marks are used to indicate direct discourse, with commas and periods set on the outside.

'I love black licorice', Jane said.

Jane said, 'I love black licorice'.

Double quotation marks are used to indicate quoted material within a quotation. Commas and periods go outside the quote marks; all other punctuation goes outside the single quotation marks.

'She is lying', I said. 'Last night I distinctly heard Jane say, "I love black licorice". I'm sure *she* ate the rest of the bag'!

Mary said, 'Last night we all heard Jane say, "I love black licorice"'.

'I know Jane said, "I love black licorice"; I was in the room!'

American English

In American English: double quotation marks are used to
indicate direct discourse, with commas and periods set on the inside.

"I love red licorice," Jane said.

Jane said, "I love red licorice."

For quoted material within a quote, set off the quoted material within the quotation
with single quotation marks. Commas and periods related to the secondary quote remain
within the single quotation marks. Any other punctuation goes on the outside.

"She is lying," I said. "Last night I distinctly heard Jane say, 'I love red licorice.'
I'm sure *she* ate the rest of the bag!"

Mary said, "Last night we all heard Jane say, 'I love red licorice.'"

"I know Jane said, 'I love red licorice'; I was in the room!"

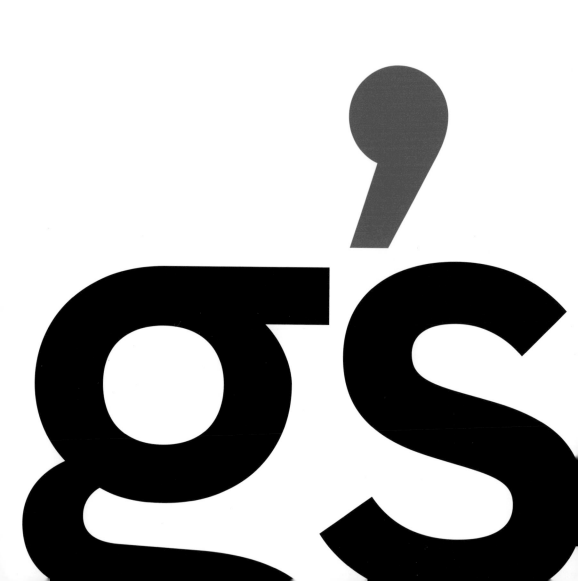

Apostrophe

Apostrophe
comes from the Greek
apostrophos (**turning away**) and
indicates where letters are missing. There
are two theories about why it represents the
possessive in English. 1. It was a contraction of
the word **his** (e.g., the **king, his** crown, land...)
2. In Old English, the genitive case showed
possession by adding **es** to end singular
masculine and neuter nouns (e.g., kinges).
With time, the **e** fell silent and
the apostrophe replaced it,
giving us **king's**.

France's royal printer Geoffroy Tory is credited with inventing the apostrophe in the sixteenth century. He also put forth the idea of the accent and the cedilla, all so that his translated French texts would better reflect their Latin roots.

’ ç ` ´

a

l'amour

Apostrophes are used in elisions to indicate unstressed letters merged or were omitted.

Contractions

use apostrophes to shorten

or combine words by

replacing letters

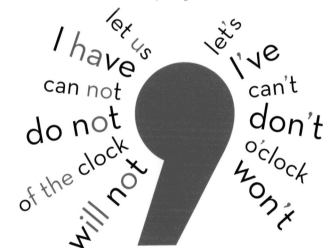

let us
I have
can not
do not
of the clock
will not

let's
I've
can't
don't
o'clock
won't

Not all contractions, however, represent straightforward elisions—
a phonetic term for the blending of sounds. Some contractions involve a vowel that changes
sound (do not > don't) or even moves position (will not > won't).

There are different terms for the loss of sound in a word,
depending on where the loss occurs:

The loss of sound at the beginning of a word is referred to as procope.

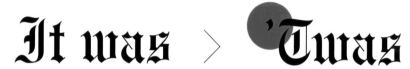

The loss of sound in the middle of a word is called syncope.

The loss of sound at the end of a word is called apocope.

Abbreviations

Apostrophes are used in certain abbreviations—e.g., continued > cont'd.

Abbreviations are never made with opening quote marks.

Apostrophes are never used to form a plural word.

Apostrophes are not used in clipped words—e.g., telephone > phone, mathematics > math, gymnasium > gym.

The possessive of most singular nouns is formed by adding an apostrophe + s to the word, regardless of its final letter.

the dog's bone

Jupiter's circumference

moss's spongy texture

the lynx's domain

The possessive of most plural nouns is formed by only adding an **apostrophe** to the word.

the dogs' summer camp

the foxes' tails

the ladies' lunches

the knives' blades

Note the differences in these two constructions.

John and Mary's parents (John and Mary share the same set of parents.)

vs.

John's and Mary's parents are friends. (John and Mary each have a set of parents.)

To form the possessive of a singular proper noun ending in a silent or a pronounced s,
add either an apostrophe + s or simply an apostrophe.

Degas's painting • Mrs. Jones's class • Socrates's philosophy

or

Degas' painting • Mrs. Jones' class • Socrates' philosophy

To form the possessive of nouns that don't form the plural with a final s,
add an apostrophe + s

the woman's club > a women's club

one child's shoe > children's shoes

a person's choice > the people's choice

one sheep's pen > sheep's pasture

one cactus's spines > cacti's spines

Possessive Adjectives / Pronouns *vs.* Contractions

Possessive adjectives (e.g., your, their) **and pronouns** (e.g., yours, theirs) never take an apostrophe. People often make the mistake of adding one, simply due to the fact that **possessive** is in the name. The more common error, though, is confusing the proper form of possessive adjectives and pronouns with contractions, which often happens when both words sound the same.

COMPARE:

Whose (possessive of **who**)

Who's (contraction of who is)

Your (possessive of **you**)

You're (contraction of you are)

Its (possessive of **it**)

It's (contraction of it is)

Their (possessive of **they**)

They're (contraction of they are)

There (in that place)

EXAMPLES:

Whose luggage is this?

Who's going to Italy?

Your country is wonderful.

You're lucky to live here.

Its scenery is beautiful.

It's a nice place to visit.

Their trip was wonderful.

They're going back next year.

They are going *there* next year.

Comma

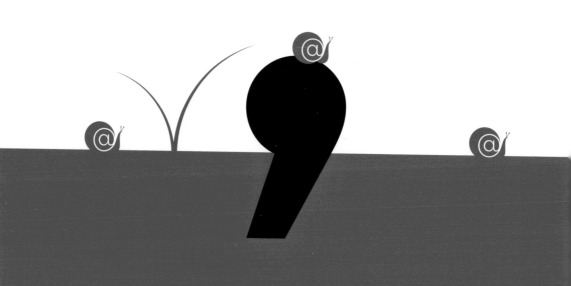

In most typefaces,
commas have the same
design as the apostrophe. Commas
are used to create a short vocal pause
and can separate words, clauses, or ideas in a
sentence. Oxford commas are the last commas
in a series of three or more items—the ones that
comes before a conjunction (i.e., and/or)—and
their necessity is subject to debate. Commas
are also used in direct address, reported
speech, and dates. Commas are used
in lieu of the decimal point
in Europe.

Lynn Truss's famous book, *Eats, Shoots & Leaves: The Zero Tolerance Approach to Punctuation*, considers how the lack or inclusion of commas can alter the meaning of a sentence.

Who

eats shoots and leaves?

verb: to ingest food

Direct object: very young plants

Direct object: foliage

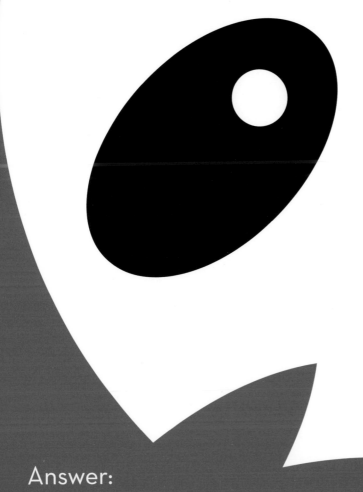

Answer:
A panda

Who

eats, *verb*: to ingest food

shoots, [Oxford or serial comma*] *verb*: to fire a gun

and *leaves?*.............. *verb*: to exit or depart

*Oxford (serial) commas go before the word **and** but not before ampersands.

BANG!

BANG!

Answer:

A hungry bank robber

Semicolon

Venetian
printer and publisher
Aldus Manutius the Elder
was the first to use the semicolon
in 1494. Like other humanists of the time,
he experimented with new punctuation in
re-issued Latin texts. As the form shows,
the semicolon is half colon and half comma.
Today it is used to join two closely related
independent clauses; these clauses
could stand alone, but are
better together.

Use semicolons to **separate** items that already have commas—e.g.,
Rome, Italy; Athens, Greece; and Vienna, Austria.

Colon

Colons:
used before quotations,
lists, and examples as well as
after the salutation of a business letter
(Dear Dr. Smith:), in math ratios (1:10), in
biblical verses (John 3:16), to separate titles
and subtitles (*Our Town: A Play in Three Acts*),
in expressions of time (lunch is at 12:30 PM,
the fastest men's marathon time is 2:01:39),
and in interviews after the letters Q and A
(Q: What was your first starring
role in a major motion
picture?).

An **em** is a unit in typography that is equal to the point size that is specified—e.g., one em in 72 point type is equal to 72 points. Point sizes are measured from the top of the ascender to the bottom of the descender.

DASHES:

Em Dash

ascender

72 points

descender

72 points

72 pt. type

Historically, in classically proportioned typefaces, such as Janson shown above, the **em dash** was the length of one em. This sometimes corresponded to the width of the uppercase **M**.

Use em dashes to:

set off a phrase—in place of commas, parentheses, or a colon

Em dashes—the longest dashes—frame a phrase.
Her answer to his proposal—yes!

attribute a quote

"Simplicity is the ultimate sophistication."
—Leonardo da Vinci

show interrupted speech

"The murderer is—" "Shhh, don't tell me!"

indicate the name of an author who has more than one book
in a bibliography (three dashes merged to form one uninterrupted line)

Carroll, Lewis. *Alice's Adventures in Wonderland*. London: Macmillan & Co., 1865.
———. *Through the Looking Glass*. Macmillan & Co., 1871.

serve as bullet points

— walk dog
— buy flowers
— mail birthday card

Some writing style guides recommend no spaces surrounding dashes. In the world of typography, the amount of space on either side of a dash is largely a matter of personal discretion. Regardless, there should be equal space on either side, with few exceptions.

DASHES:

En Dash

An **en** is a unit in typography that is equal to half an em—i.e., half the point size that is specified. For example, one en in 72 point type is equal to 36 points.

36 points

72 points

72 pt. type

fgn

Historically, in classically proportioned typefaces, such as Janson shown above, the **en dash** was the length of one en. This sometimes corresponded to the width of the lowercase **n**.

Use en dashes to:

show intervals or ranges
9–5
Monday–Friday
pages 122–34

join affixes (prefixes and suffixes) to compound nouns
post–World War II
Audrey Hepburn–like

join compound elements to other compound elements
Academy Award–winning actor

to write directions, votes, and sports scores when the sense of **to** is meant
New York–Rome flight
The Senate passed the bill with a 50–51 vote.
The Yankees defeated the Mets 4–1.

In the Renaissance, italic fonts had angled hyphens (-). At one point, hyphens could be doubled (=) so that they would not be confused with the comma, which at the time could also be written as an inclined stroke. From 1949 to 2009, the name of the Waldorf=Astoria hotel used a double hyphen.

Hyphen

Word spacing didn't come into being until the late seventh century, when monks in Ireland began adding space between words, referred to as "aerating" text.

In ancient Greece, text was written in a continuous script, so scribes used hyphens ὑφ' ἕν (pronounced huph' hén and meaning **under one**) under adjacent letters to join them. Just as musical ties connect notes, the hyphens indicated that the letters were to be read as one.

When Johannes Gutenberg printed his forty-two-line Bible, he made the lines all the same length by breaking words and then held the loose letters in place against the frame by adding hyphens at the end of each line. The hyphen indicated that the word continued and it still does today. As with other punctuation, hyphens are used to make writing clearer.

Use hyphens in compound words:

to express numbers between twenty-one and ninety-nine
thirty-five

that form nouns or dual names
great-grandfather, Jean-Paul Sartre, Henri de Toulouse-Lautrec

that are adjectives that precede a noun, but not following it
full-time employee vs. the employee worked full time.

that are adjectives formed with adverbs, except **very** and those ending in **ly**.
slow-crawling snail vs. very entertaining movie, highly paid employee

Use hyphens with prefixes and suffixes:

especially when they result in the same vowel repeating
ex-president, president-elect, de-escalate, anti-immune, co-occur

always when they precede a proper noun, abbreviation, or acronym
trans-Atlantic journey, ex-Mrs. Richards, non-NATO ally

to avoid confusion with non-prefix words that are spelled the same
but have a different meaning
re-sign (to sign again) **vs. resign** (to voluntarily leave a job)

to avoid ambiguity with non-prefix and non-suffix words.
twenty one-year-olds (twenty infants) **vs. twenty-one-year-olds** (an age group)

Ellipsis

The
ellipsis (plural, ellipses)
is a single character that consists
of three pre-spaced dots. The name comes
from the Greek word *elleipein* (**to leave out**).
Its function is to indicate that text has been omitted
from a quoted passage. Ellipses are not used at the
beginning of a quote, even if the beginning of the
sentence has been eliminated. They are not used
at the end of a quotation for the same reason,
unless the cited sentence is intentionally
incomplete. If that's not the case, a
period is added before the
ellipses.

● ● ●

Typography in the Digital Age

Typewriters lacked enough keys to type all the necessary characters, so people made do with the existing keys. Since typewriter fonts were monospaced, two spaces were needed after the period at the end of a sentence. There was no dedicated exclamation point key. Instead apostrophes were backspaced over a period, and ellipses were made by typing three individual periods (. . .).

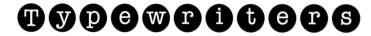

Computers

Computer technology can create correct typographic characters and optical spacing, so only one space is needed after a period that ends a sentence (once universally called a full stop for its role in that function). The distinction of use is made because a period used in a URL or as a decimal point has no space after. The period, the space between the two sentences, and the capital letter beginning the following sentence are all sufficient signals that one sentence has ended and a new one is beginning. Computer fonts optically space characters and have a rich variety of glyphs, including a dedicated ellipsis character (…).

These typewriter keys were used... to approximate these characters:

— / – –

One or two hyphens

— / —

En dash and em dash

'

Single dumb quote

' / ' / '

Opening and closing quotation marks and apostrophe

"

Double dumb quotes

" / "

Opening and closing double quotation marks

. + ' = !

Period plus single dumb quote

Exclamation point

• • •

Three periods

Ellipsis

How to Type the Correct Characters on a Windows PC

The most commonly used punctuation marks and symbols are marked on the keyboard.
Opening the Character Map app in Windows OS will show you all the glyph possibilities a font offers.

 + ?

You can also type the full set of characters by typing the **Alt key** followed by the numbers on the page to the right. NOTE: You must use the numeric key pad on the right of the keyboard with the number lock activated if using this method.

In addition, every character is given a unique Unicode number. On a Mac and on a PC, using this number ensures that the correct character will be used when available within a font. Choosing a character by mere appearance is not always a reliable method as many different characters have similiar glyphs.

		ALT KEY +			UNICODE		
!	Exclamation Point	33			U+0021		
@	At Symbol	64			U+0040		
#	Number	35			U+0023		
%	Percent	37			U+0025		
¶	Pilcrow	20			U+00B6		
&	Ampersand	38			U+0026		
*	Asterisk	42			U+002A		
()	Parentheses	40	41		U+0028	U+0029	
- – —	Hyphen En Dash Em Dash	45	0150	0151	U+002D	U+2013	U+2014
{ }	Braces	123	125		U+007B	U+007D	
[]	Brackets	91	93		U+005B	U+005D	
:	Colon	58			U+003A		
;	Semicolon	59			U+003B		
…	Ellipsis	0133			U+2026		
" "	Double Quotation Marks	0147	0148		U+201C	U+201D	
' '	Single Quotation Marks	0145	0146		U+2018	U+2019	
?	Question Mark	63			U+003F		
,	Comma	44			U+002C		
.	Period	46			U+002E		
/	Slash	47			U+002F		

How to Type the Correct Characters on a Mac

The most commonly used punctuation marks and symbols are marked on the keyboard. The Keyboard Viewer in Mac OS will show you the other possibilities you can achieve by pressing different key combinations.

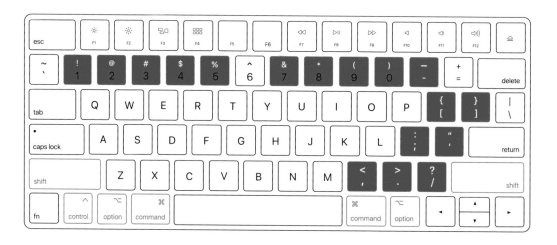

Many programs also have a glyph palette that shows the full range that is available for each font. Typing in the name or the Unicode number will highlight the character in the chart while clicking on the character in the chart will show the name and the Unicode number for verification.

!	Exclamation Point
@	At Symbol
#	Number
%	Percent
¶	Pilcrow
&	Ampersand
*	Asterisk
()	Parentheses
- – —	Hyphen En Dash Em Dash
{ }	Braces
[]	Brackets
:	Colon
;	Semicolon
...	Ellipsis
" "	Double Quotation Marks
' '	Single Quotation Marks
?	Question Mark
,	Comma
.	Period
/	Slash

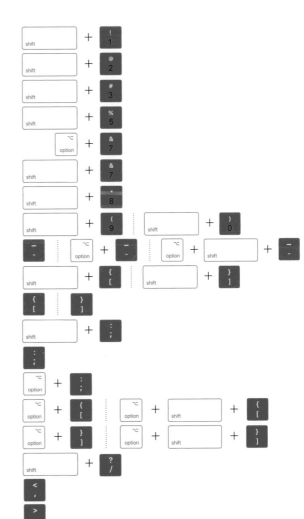

Emoticons

Western emoticons are read by turning the head 90 degrees to the left.

:-)	:-D	:-(:-P	:-O	;-)
Smile	Laugh	Frown	Tongue out	Surprise	Wink

日
本
語

Emoticons are typographic characters used to create facial expressions. The name is a portmanteau of **emotion** + **icon**. Eastern emoticons originated in Japan, where they are called *kaomoji* (顔文字 = **face characters**). Much like the earliest punctuation, they are used to instruct how written speech is to be read and are almost a full-circle return to the pictographic nature of early written language.

Japanese emoticons are read from left to right.

(~_~;)

Nervous

(*_*)

Amazed

(>_<)

Troubled

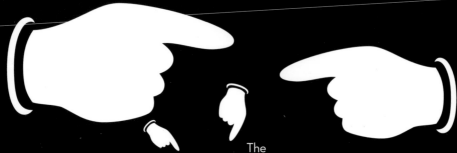

The
future of punctuation
is unknown. Punctuation
changes form, name, and usage over
time. It also falls in and out of favor. In this
digital age of instant messaging, tweets with
limited characters, and shortening attention
spans, the prospects for attending to the details
are looking more and more grim. Ironically,
the oft-forgotten semicolon appears in the
acronym of the times: **tl;dr**—i.e., "too long;
didn't read." For punctuation, will it
be a full stop or an ellipsis…?
¯_(ツ)_/¯

The now-rare "pointing hand" symbol, or manicule (from Latin *maniculum* for **little hand**), was in most frequent use during medieval times and the Renaissance. In the nineteenth century, it was used on signage and advertisements—even on wanted posters and gravestones—more often than in books. It has survived in recent years as an early version of the cursor and in various emojis.

* * *

Useful Terms

Allograph
Each of two or more alternate ways to write a letter (e.g., **a** vs. **a**, or **g** vs. **g**) or sound (e.g., **f** vs. **ph**).

Aphesis
The loss of an unaccented vowel at the beginning of a word (e.g., around > round).

Apocope
An omission of letters at the end of a word.

Aposiopesis
A trailing off of speech, from the Greek for **becoming silent**.

Asterism (⁂)
Triangular configuration of asterisks that signals a break in text.

Boustrophedon
Ancient Greek practice of writing left to right, then right to left in alternating lines from the Greek for **ox** and **turn** as it mimics the movement of oxen plowing a field.

Bowdlerization
Expurgation, after Dr. Thomas Bowdler, the publisher of a censored edition of Shakespeare in 1818.

Character
A symbol representing a letter, numeral, or punctuation mark.

Diesis (‡)
Alternate name for double-dagger mark.

Dinkus (∗∗∗)
Three asterisks used in a horizontal row to indicate the end of a chapter or a book.

Diple (›)
From Greek διπλῆ (**double**), an early punctuation symbol that was put in the margins to bring attention to a part of the text.

Distinctiones
A series of dots used to denote where pauses should occur in ancient orations and for how long they should be. In Greek they were referred to as *theséis*.

Eroteme (?)
A name for the question mark.

Font
The actual physical set of characters within a particular typeface family that is used to produce typographic works. From the Old French *fondre* (**to melt**) in reference to the molten lead that was cast to make the metal type used in printing.

Glyph (e.g., ɑ/a/a/a/a/a)
A specific version of a typographic character.

Grapheme
In writing systems, the smallest unit of letter(s) used to represent a phoneme.

Grawlix
A string of typographic symbols used in place of spelling out obscenities, especially in comic strips.

Guillemets (« ») (‹ ›)
Pair of double or single chevron marks used to enclose quotations in several European languages.

Hedera (❦)
From the Latin for ivy, an ornamental typographic symbol used to adorn and show breaks in printed texts. Also called a *fleuron*, derived from the French *fleur* (**flower**).

Interrobang
A character that is the combination of a question mark and an exclamation point (bang).

Ligature (e.g., fi / fl / ffi)
A combination of two or more letterforms into a single glyph.

Logogram
A character or symbol that stands for an entire word. Chinese characters and hieroglyphics are typically logograms.

Malapropism
The substitution by a speaker or a writer of one word for a similar sounding one. The term derives from a French phrase that means "badly for the purpose."

Mondegreen
A new meaning resulting from mishearing or misinterpreting a word or a phrase. The word itself is a mondegreen. It came into being when writer Sylvia Wright heard "Lady Mondegreen" rather than this line of poetry: "laid him on the green."

Obelisk (†)
Alternate name for the dagger mark.

Obelus (÷)
Ancient symbol that evolved into the dagger mark (†). It's used today as the division sign.

Octothorp(e) (#)
Another name for the hash symbol. From the Latin *octo* (**eight**) and last name of Olympian Jim Thorpe.

Orthographic
From the Greek *ortho* (**correct**) and *graphos*, (**writing**). It refers to the spelling of a language.

Per mille (‰)
Latin for **for / by thousand**.

Permyriad (‰o)
Latin for **for / by ten thousand**.

Phoneme
A distinguishable unit of sound in a language, often represented by more than one grapheme (e.g., /k/ = c and k).

Portmanteau
A word invented by combining the sounds and meanings of two separate words. Its name is derived from the French word for a traveling case with hinges joining the halves. It was coined by Lewis Carroll in the 1870s to refer to terms in his poem "Jabberwocky."

Procope
An omission of letters at the beginning of a word. Also called *apheresis*.

Syncope
An omission of letters in the middle of a word.

Tilde (~)
A grapheme used as a diacritical mark, primarily in Spanish and Portuguese; in math, a symbol for approximation. In Spanish, the word *tilde* refers to any accent mark.

Typeface
A set of complete characters designed to be used together, including letters, numbers, punctuation marks, and symbols.

Unicameral
A typographic character whose design is the same in both upper and lower case.

 Index (from the Latin *index, indic* (**forefinger**)

Snails & Monkey Tails

HarperCollins books may be purchased for educational, business, or sales promotional use.
For information please e-mail the Special Markets Department at SPsales@harpercollins.com.

First published in 2021 by
Harper Design
An Imprint of HarperCollins *Publishers*
195 Broadway
New York, NY 10007
Tel: (212) 207-7000
Fax: (855) 746-6023

harperdesign@harpercollins.com
www.hc.com

Distributed throughout the world by
HarperCollins *Publishers*
195 Broadway
New York, NY 10007

ISBN 978-0-06-306124-8

Library of Congress Control Number:
2021016284

Book and cover design by Michael Arndt

Printed in Thailand

First Printing, 2021

About the Author and Designer

Michael Arndt
studied graphic design at the
University of Cincinnati. He is the
author and illustrator of several books.
His passion for language and typography
inspired this book. Michael lives in New York
City and when he is not playing in Central Park
with his dog, Clooney, or working at home
with his cat, Greta, he can be found
online correcting other ~~peoples~~
people's punctuation.